W9-BEW-276

Faces of Hope
10 Years Later
Babies Born on 9/11

Christine Pisera Naman

Health Communications, Inc.
Deerfield Beach, Florida

www.hcibooks.com

Library of Congress Cataloging-in-Publication Data
is available through the Library of Congress.

©2011 Christine Pisera Naman

ISBN-13: 978-0-7573-1626-5
ISBN-10: 0-7573-1626-3
ISBN-13: 978-0-7573-9168-2 (e-book)
ISBN-10: 0-7573-9168-0 (e-book)

All rights reserved. Printed in the United States of America. No part of this publication may be reproduced, stored in a retrieval system, or transmitted in any form or by any means, electronic, mechanical, photocopying, recording, or otherwise, without the written permission of the publisher.

HCI, its logos, and marks are trademarks of Health Communications, Inc.

Publisher: Health Communications, Inc.
 3201 S.W. 15th Street
 Deerfield Beach, FL 33442–8190

Cover image ©iStockphoto
Cover design by Larissa Hise Henoch
Interior design and formatting by Lawna Patterson Oldfield

This book is dedicated to
the memory of

Christina Taylor Green

September 11, 2001–January 8, 2011

Contents

Introduction

September 11, 2001. It has been ten years since that fateful day, a day that will forever live in our minds and hearts, a day forever imprinted upon us. It will live vividly in our minds because everyone remembers where they were, who they were with, and what they were doing. It was a day that will live forever in our hearts because all hearts were touched; more aptly put, all hearts were bruised, and those bruises still exist today. Everyone remembers how they felt, our collective breath taken away with the reality that 3,000 lives were lost—innocent people who were simply doing what they do.

Ten years have passed. It seems like long ago, yet it seems like just yesterday. Like yesterday, the wounds are still raw, with those lost never far from our minds and hearts. Yet, much has changed in ten years. Time marched on; we all got a little older and a little wiser too, I believe.

From a personal perspective, nowhere has the growth of ten years been more evident than in the faces of the children born on that tragic day. On that day we were blessed with beautiful baby boys and girls all innocent and new. Now those babies are lively, active ten-year-olds. Still innocent and still fairly new, I guess, but at the same time much older.

In the first book, *Faces of Hope: Babies Born on 9/11*, we captured the faces of infants with their amazing wide eyes and toothless grins. We wished them all the most precious wishes of childhood—all of the moments one would hope the perfect childhood would hold—and sent them on their way.

Now, ten years later, we have an updated *Faces of Hope* book with the same babies who have turned into "big kids." You will enjoy seeing how they have grown. The children still have wide eyes, but now their grins are toothy. They are full of life and have some experience under their belts. They know things. That couldn't be helped. September 1, 2001, is a part of our history and is in the textbooks that they read. They know that 9/11 exists and will always exist; they know that 9/11 will always be their birthday. It is a weighty birthday for sure, but it is one that they can handle. On these anniversaries, like all of us they honor those lost, pausing and praying for them and their families. But unlike everyone else, they also celebrate the new life that they were and the amazing

beings they have become. Months ago, as the children approached their tenth birthdays, I began wondering where they are now and what they think of the world in which they were born. In all, they think it is a pretty great place. I agree with them. I wondered how they see our country and asked them to draw about it. I am biased, but I think that the pictures are remarkable. The orginal *Faces of Hope* was written solely by adults. This time the children had a hand in it through their drawings. Through these pictures we are able to see the way that they see the world, the way that only ten-year-olds can see. I hope you will enjoy the photographs of the "artists." The magic in their eyes is evident. I also hope that you enjoy the drawings as much as I do. My prayers were answered when I discovered that what they saw most in our country was hope.

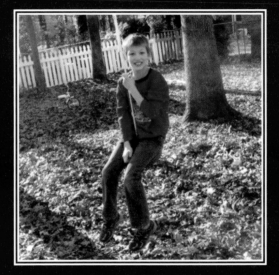

James Michael Blake ★ Alabama ★ 9:27 A.M.

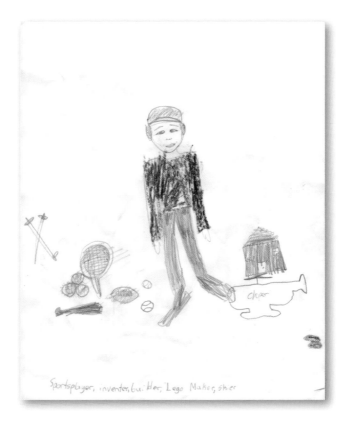

Sportsplayer, inventer, builder, Lego Maker, skier

"I will make the world a better place by being an archeologist for a children's museum. Kids will see interesting things and learn from them."

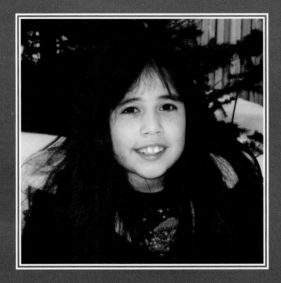

Alyse Shania ★ Alaska ★ 12:24 P.M.

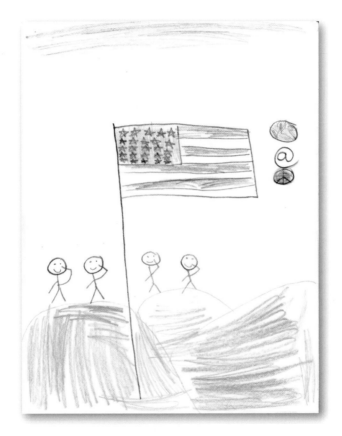

"I will make the world a better place
by cleaning up beaches to protect our wildlife."

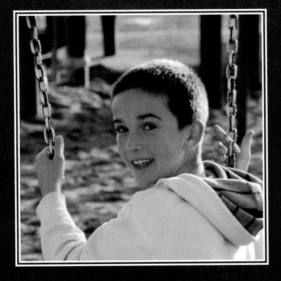

David Michael ★ Arizona ★ 10:24 PM

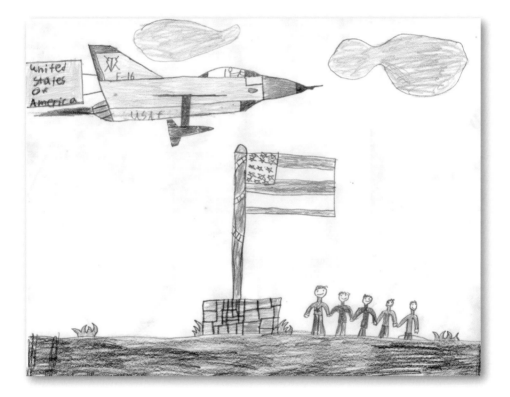

"I will make the world a better place by joining the Air Force and serving our country. My dad serves this country."

Harrison Graham ★ Arkansas ★ 5:22 P.M.

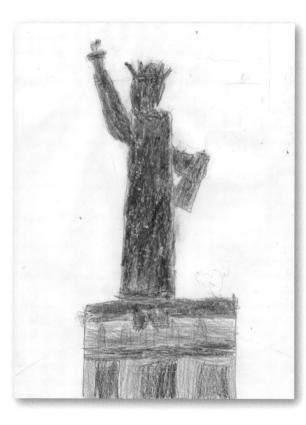

"I will make the world a better place by becoming a doctor and saving lives. The day I came into the world, the Twin Towers collapsed and many people died. My mom says that I was a bright spot on a dark day, and if other catastrophes happen in our country I'll always be ready to help others."

Chelsea Celeste ★ California ★ 6:49 P.M.

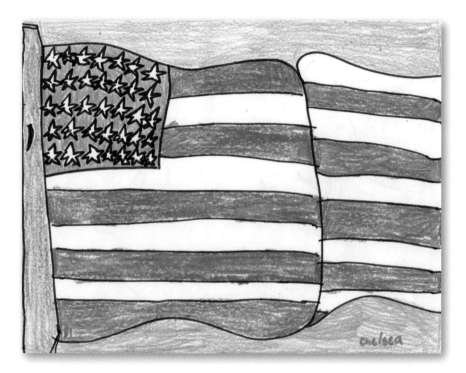

"I will make the world a better place by becoming
a rock star, and all the money I make will be divided,
half for me, and the other half goes to children's hospitals.
The money I give them will help buy toys and stuff
like that for all the kids to play with."

Seth Joseph ★ Colorado ★ 7:01 P.M.

"I will make the world a better place by probably being the world's best president. I would make laws that are fair to everyone to make the world a better place."

Madelyn Jayne ★ Connecticut ★ 3:05 P.M.

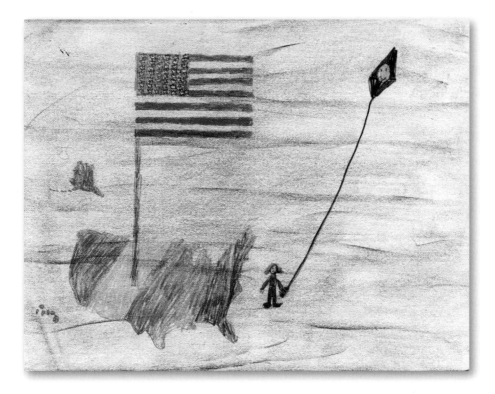

"I will make the world a better place by recycling,
not littering, and helping to save the world. I could also help
the world when I grow up because I want to be an artist,
and I can use recyclable supplies when I work."

Laura Kathryn ★ Delaware ★ 6:01 A.M.

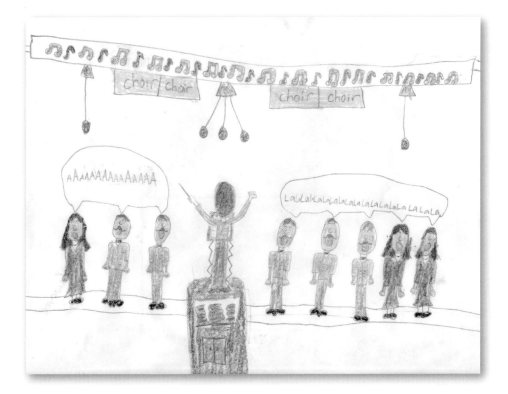

"I will make the world a better place by going out
and broadcasting God's love all over the world."

Christian Blake ★ Florida ★ 9:48 A.M.

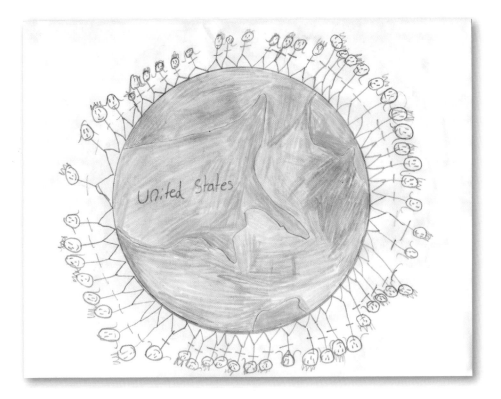

"I will make the world a better place, be president,
and give out lots of money and stop all wars."

Ellie ★ Georgia ★ 5:15 P.M.

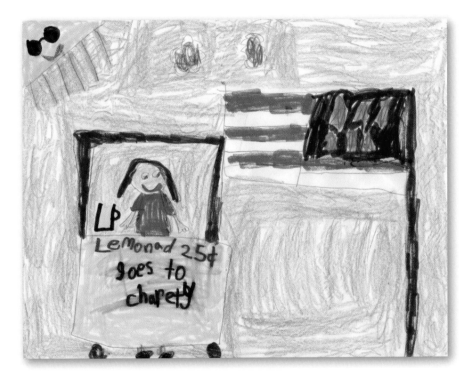

"I will make the world a better place because I will treat other people the way I want to be treated. Like if someone falls and it's really, really, really bad, then you should call for help. But if it's only sort of bad, you just offer your hand to help them up, and maybe a Band-aid or something."

Krystal Chino ★ Hawaii ★ 2:56 P.M.

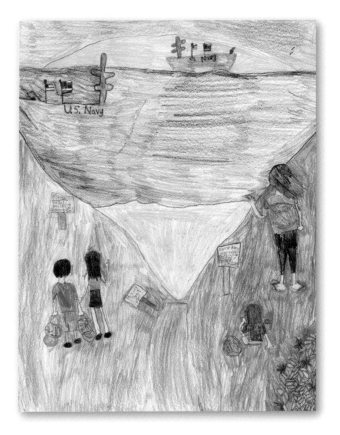

"I will make the world a better place by helping discover new things and helping people less fortunate than I am."

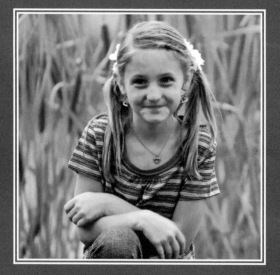

Jenna Kay ★ Idaho ★ 1:13 P.M.

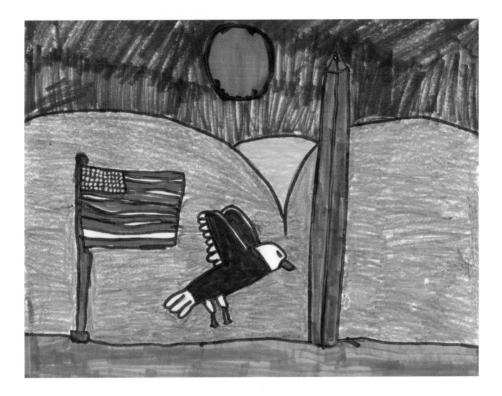

"I will make the world a better place.
I want to be a zookeeper when I grow up so I can
keep the animals safe and happy. Then when people
come to see them the kids will be happy."

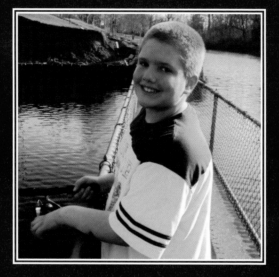

Jacob Michael ★ Illinois ★ 2:46 A.M.

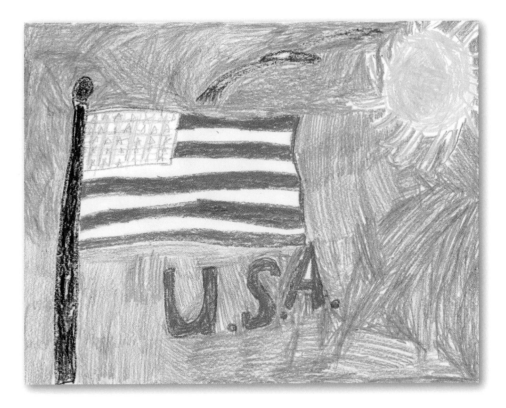

"I will make the world a better place. When I grow up
I want to be a firefighter just like my grandpa and my dad.
It takes a brave person to do this job."

Isaac Gregory ★ Indiana ★ 9:54 A.M.

"I will make the world a better place by being a farmer and producing crops to feed all the people in the world."

Colton Michael ★ Iowa ★ 3:30 A.M.

"I will make the world a better place because I have a lot of strengths, good attitude, and some true ability that will be enough to take me where I always want to be."

Savannah Grace ★ Kansas ★ 2:48 P.M.

"I will make the world a better place by
giving up my stuff for the poor."

Draven Cale ★ Kentucky ★ 6:47 P.M.

"I will make the world a better place by making more jobs for the people that live in the United States."

Colby Allen ★ Louisiana ★ 8:17 P.M.

"I will make the world a better place by inventing stuff."

Seth Michael ★ Maine ★ 7:50 AM

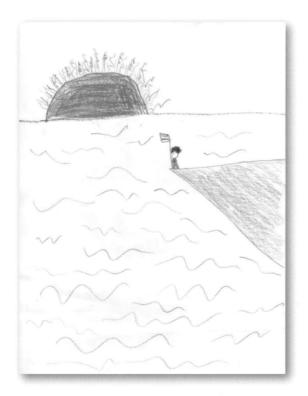

"I will make the world a better place by recycling and never littering, and I will clean up all the mess that people leave behind. When I grow up, I want to help people who need help and to help keep our country safe."

Christina Taylor ★ Maryland ★ 12:50 P.M.

September 11, 2001–January 8, 2011

"If there are rain puddles in heaven, Christina is jumping in them today."-President Barack Obama in his address to the nation, memorial speech in Arizona, 2011

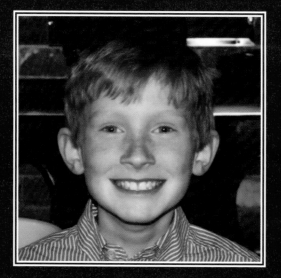

Duncan Andrew ★ Massachusetts ★ 3:14 A.M.

"I will make the world a better place by becoming an
engineer and helping to design things for space exploration,
like a new rocket with a better emergency escape system.
I would also like to work on 'green' factories and
houses as well as better cars and jets, and maybe
something to help recycling at the dump."

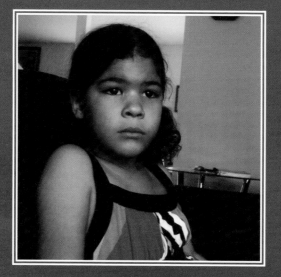

Raé Anna Nichole ★ Michigan ★ 2:19 A.M.

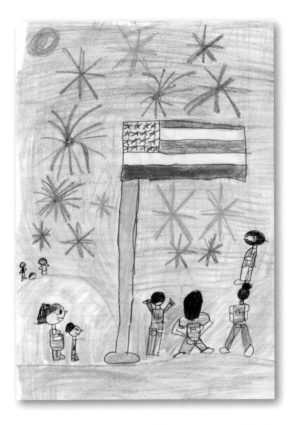

"I will make the world a better place by being a
part of 'Friends for Change,' where you fix dirt roads
and plant things, making the world a better place."

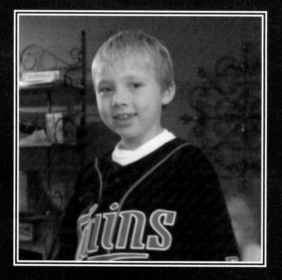

Nicholas Robert ★ Minnesota ★ 9:11 P.M.

"I will make the world a better place by helping young
and old, hurt or helpless people and animals."

Andrew Dillon ★ Mississippi ★ 9:45 A.M.

"I will make the world a better place by being a bus driver.
Bus drivers make sure all kids can get to school."

Mary Claire ★ Missouri ★ 8:09 P.M.

"When I grow up I am going to be a vet, an artist, or an engineer. But for sure, I am going to be a mommy. A mommy is nice, loving, and caring, which makes the world a better place."

Michael John ★ Montana ★ 8:43 P.M.

"I will make the world a better place by helping people and doing good things. I want to play sports. I want to be kind to people and make them smile. When I retire from sports, maybe I will be a priest."

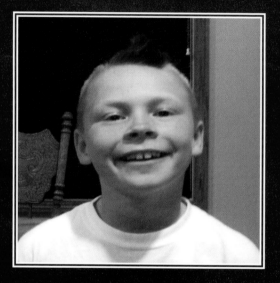

Samuel James ★ Nebraska ★ 4:59 P.M.

"I will make the world a better place. I want to have the world 'go green,' and I will be responsible."

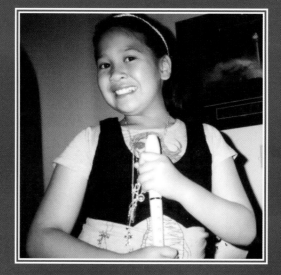

Tyra Ann ★ Nevada ★ 3:07 A.M.

"I will make the world a better place by
donating to a charity to end world hunger."

Matthew Thomas ★ New Hampshire ★ 4:3

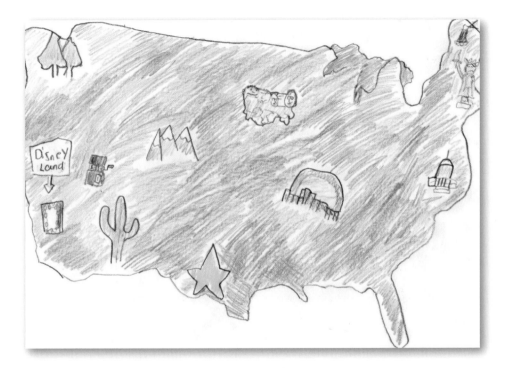

"I will make the world a better place by donating money to charities like SPCA. I want to be in the NBA when I grow up. I will use my money to help people and animals."

Anish ★ New Jersey ★ 10:05 A.M.

"I will make the world a better place by inventing a machine that could recycle all our garbage into useful material and keep us and animals healthy."

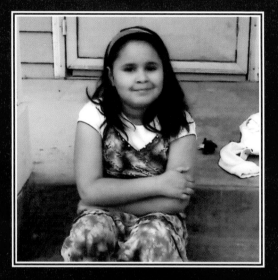

Kelsey Erin ★ New Mexico ★ 8:29 A.M.

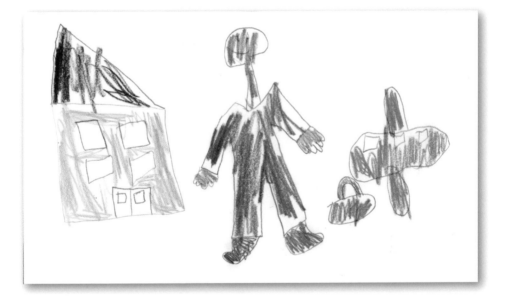

"I will make the world a better place by becoming an
actress so that I can make people laugh and smile."

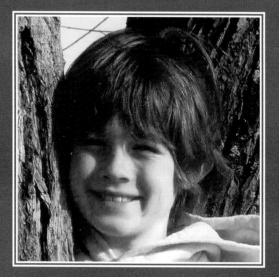

Jacob Robert ★ New York ★ 12:23 P.M.

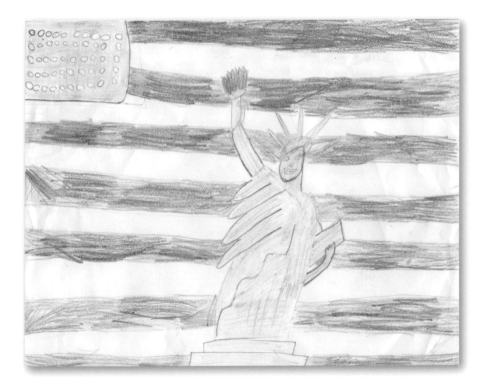

"I will make the world a better place by going in the woods and cleaning all the trash. And then if I see a sick animal I will help it out and ask if I could take it to the vet. That's how I'll make the world a better place."

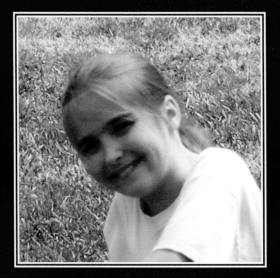

Alexis Taylor ★ North Carolina ★ 11:47 A.M.

"I will make the world a better place by being a rock star in a band and making great music and doing lots of charity concerts."

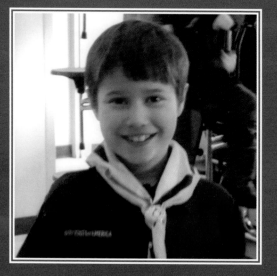

Jay Lee ★ North Dakota ★ 7:58 A.M.

"I will make the world a better place by helping
the citizens and protecting them."

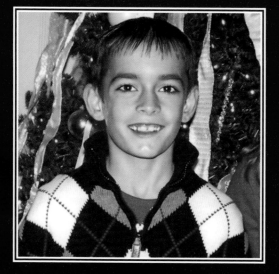

Maxwell Stephen ★ Ohio ★ 12:07 A.M.

"I will make the world a better place by recycling . . .
Going green . . . Everyone should . . . I want to be an engineer,
so I'll probably work on making enough electric cars so
no one has to drive gas-powered ones anymore."

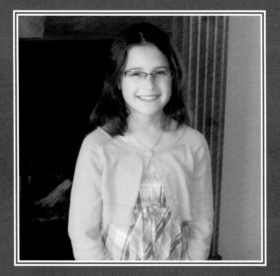

Sarah Brett ★ Oklahoma ★ 8:19 P.M.

"I will make the world a better place by recycling,
volunteering to help people, and being nice."

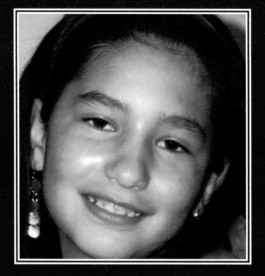

Ana Maria ★ Oregon ★ 5:42 P.M.

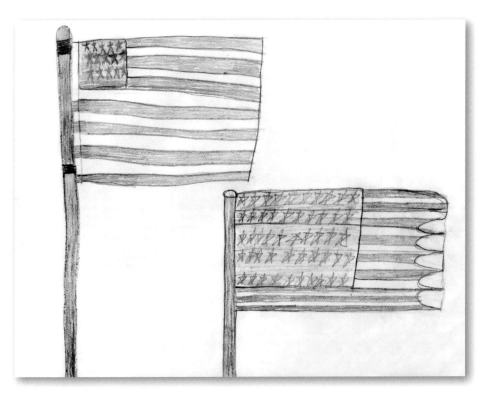

"I will make the world a better place by taking care
of the earth and helping other people. I can open doors,
be kind, nice, gentle, and love others."

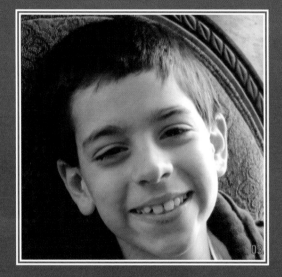

Trevor Sami ★ Pennsylvania ★ 2:07 P.M.

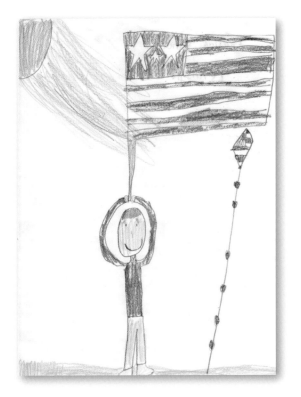

"I will make the world a better place by going
to hospitals when I become a hockey player and sign
autographs for the kids and give them jerseys."

Lilly Marie ★ Rhode Island ★ 12:38 P.M.

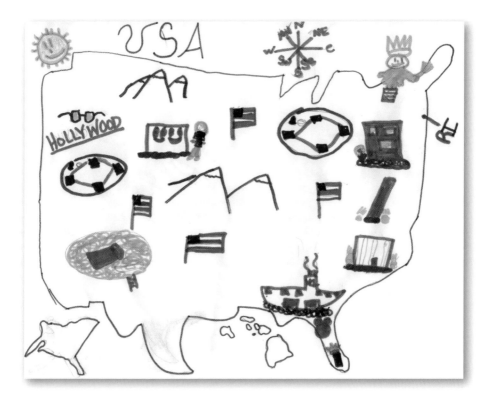

"I will make the world a better place by becoming a
gymnastics coach. I love to help children with gymnastics.
I also love to do gymnastics."

Carson ★ South Carolina ★ 5:18 P.M.

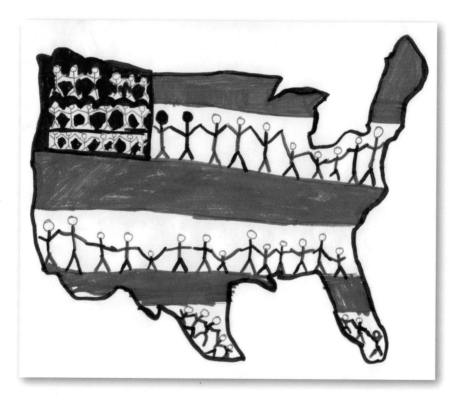

"I will make the world a better place by helping
the environment. I'm going to pick up trash
and dig for and discover a new dinosaur."

Katie Rose: 5:54 P.M. ★ South Dakota ★ Kathie Jean: 5:43 P.M.

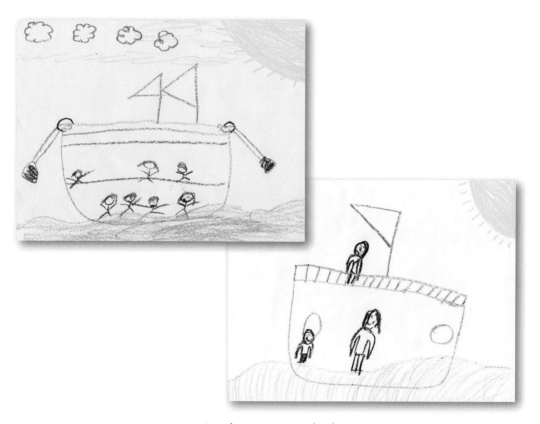

"I will make the world a better place by becoming a doctor so
I can keep kids and moms and dads safe and not sick." —Katie Rose

"I will make the world a better place by being a
teacher so people are smart." —Kathie Jean

Benjamin ★ Tennessee ★ 1:44 P.M.

"I will make the world a better place by
becoming a president and making great and fair laws.
I want there to be peace on earth."

Carson Wil; 7:56 A.M. ★ Texas ★ Collin Levi; 7:57 A.M.

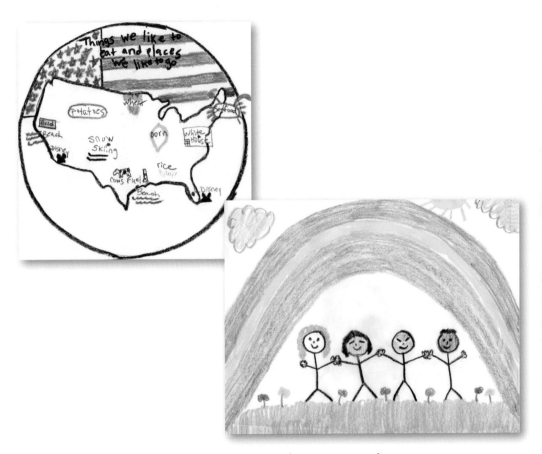

"We will make the world a better place by making
people laugh and giving big hugs."

Hayes Christopher ★ Utah ★ 5:24 A.M.

"I will make the world a better place by recycling, helping people, stopping pollution, and setting a good example."

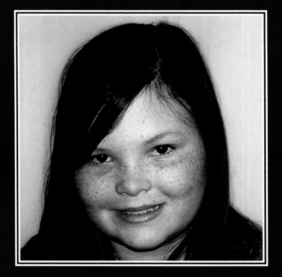

Emma ★ Vermont ★ 11:03 A.M.

"I will make the world a better place by being a hairdresser.
Someday I hope to own my mom's hair shop."

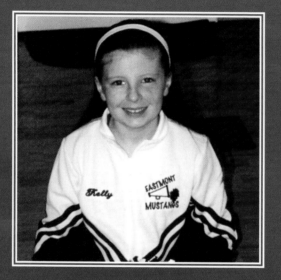

Kelly Brooke ★ Virginia ★ 2:39 A.M.

"I will make the world a better place by making medicine.
I will make a cure for cancer. I hate the thought
that people are suffering from it right now. People die
from it every day. I want to change that."

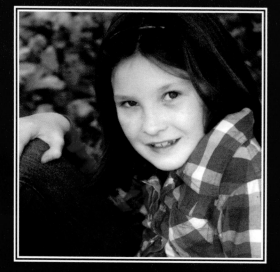

Jayna ★ Washington ★ 6:00 P.M.

"I will make the world a better place by
being an ambulance driver who drives sick people
to the hospital so they can get better fast."

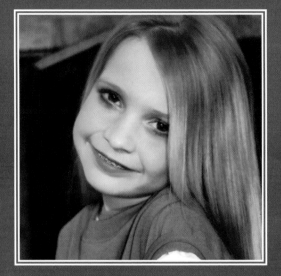

Hattie Elaine ★ West Virginia ★ 11:15 A.M.

"I will make the world a better place by becoming a
veterinarian. I can save and work with all types of animals."

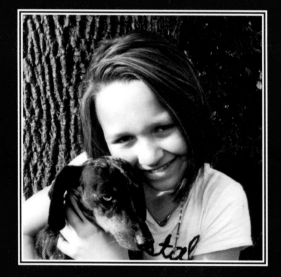

Karis ★ Wisconsin ★ 4:16 P.M.

"I will make the world a better place by saving
animals that have been abused or abandoned."

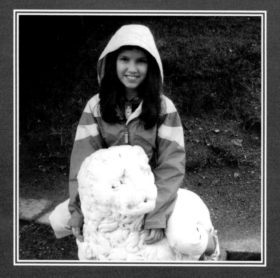

Leah Alta ★ Wyoming ★ 12:14 P.M.

"I will make the world a better place by becoming a teacher.
All children need a good education for their future. I will teach
them reading and writing, math and science, art, and lots of other
subjects. If all children are safe and have enough to eat and
get a good education, the world will be a much better place, and
we all will be good to the earth and the people and the animals
and find cures for diseases instead of fighting in wars."

Afterword

There are more than ten thousand babies in the United States that share the birthday of September 11, 2001. Each and every one of them is a Face of Hope. But more than that every baby born, every day, everywhere is a Face of Hope, a little being who represents all that is pure and perfect, a brand-new life full of promise and limitless potential, the potential to do right and good and to make this world a better place. To them I wish a childhood full of wonder, laughter, and joy followed by an adulthood made of self-fulfillment and goodness. I just know they will have it.

Acknowledgments

To Bonnie Solow, thank you for being my agent, but most of all, thank you for being my friend. Somehow you are always out there believing in me. How does it feel to be a blessing in someone else's life? You are in mine.

To Doreen Varuolo, thank you does not seem like it is enough to say for all of the times you were there for me. But from the bottom of my heart, thank you. How many times did you take me in, give me a cup of tea, and tell me that I really could do things that I was sure that I couldn't? It was many. Always patient. Always kind. Always a friend.

To Patty Aubery, who was the first one to reach out, believe, and take a chance. To you, my friend, I will always be grateful.

To Casey and Mel Kenaston, who are all things good. Thank you.

Babies Born on a Day of Horror Live a Life of Hope

Dedicated to the memory of
nine-year-old Christina Taylor Green, who was the youngest of six victims
shot and killed on January 8, 2011, during the shooting spree
at Rep. Gabrielle Giffords's political event in Tucson, Arizona,
Faces of Hope Ten Years Later continues the celebration
of life born amid the darkness of tragedy.
Christina, born on 9/11, was among the fifty children
profiled in 2001's edition of *Faces of Hope: Babies Born on 9/11*, and now her
legacy is joined by 49 other children, who, ten years after their birth, have
something to share and teach about hope, wonder, and dreaming big dreams.
Boasting glimmering wide eyes and toothless grins, the first
Faces of Hope captured the essence of infants born on 9/11.
Now, ten years later, the same babies have grown into
"big kids," full of life, love, and wisdom. And through their beautiful photos,
inspirational quotes, and innocent drawings,
they share their visions of how to contribute to this world.

About the Author

Christine Pisera Naman is the author of *Faces of Hope: Babies Born on 9/11* as well as *Caterpillar Kisses, Christmas Lights,* and *The Believers.* She lives in Monroeville, Pennsylvania, with her husband and three children.

Guess Who? Can You Match the Babies to Their "Big Kid" Pictures?

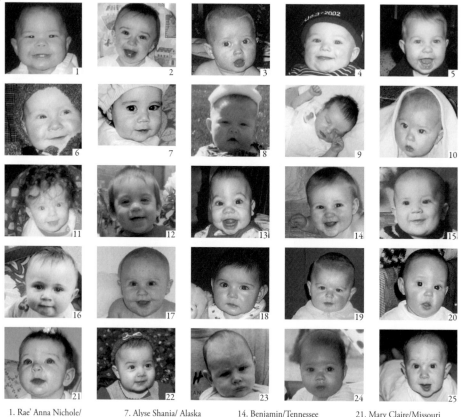

1. Rae' Anna Nichole/ Michigan
2. David Michael/Arizona
3. Jay Lee/North Dakota
4. Hayes Christopher/Utah
5. Michael John/ Montana
6. Duncan Andrew/ Massachusetts
7. Alyse Shania/ Alaska
8. Jayna/Washington
9. Alexis Taylor/ North Carolina
10. Savannah Grace/ Kansas
11. Kelly Brooke/Virginia
12. Trevor Sami/Pennsylvania
13. Seth Joseph/Colorado
14. Benjamin/Tennessee
15. Draven Cale/Kentucky
16. Andrew Dillon/Mississippi
17. Harrison Graham/ Arkansas
18. Leah Alta/Wyoming
19. Carson/South Carolina
20. Kelsey Erin/New Mexico
21. Mary Claire/Missouri
22. Christina Taylor/ Maryland
23. Christian Blake/Florida
24. Krystal Chino/Hawaii
25. Matthew Thomas/ New Hampshire